INTRODUCTION

What comes to mind when you think of a triangle? Depending on its size, it could be a pyramid, a clown's hat, a slice of pie, or a bird's beak. What if there are lots of triangles on a page? Depending on how they're placed, they might suggest a mountain range or a pine tree farm, a gathering of witches or a sailboat race—it all depends on who is doing the looking.

This is a draw-in book for doodling, for loosening the imagination, and for inspiring creative thought. Triangles appear as prompts on every page: one or many, large and small, colorful or not. Some appear to sprout from the bottom of the page, some tumble from the top—you fill in the rest. If one triangle suggests the roof of a house, you might add just the doors and windows, or you could draw the entire town. If a row of triangles looks like waves, you might complete a fantasy seascape with dolphins and mermaids and a desert isle, or simply add a lonely seagull or a swimmer in mid-crawl.

Abstract or realistic, minimal or over-the-top, all ideas are welcome in this book—and you don't even have to be an artist to complete the pictures. Just pick up your pencils, crayons, and markers, and doodle where your imagination leads you.

HOW TO DOODLE THIS BOOK

What do you see? Draw what you see.

100 THINGS
TO DRAW WITH A
TRIANGLE

Start with a shape;
doodle what you see.

SARAH WALSH

QUARRY

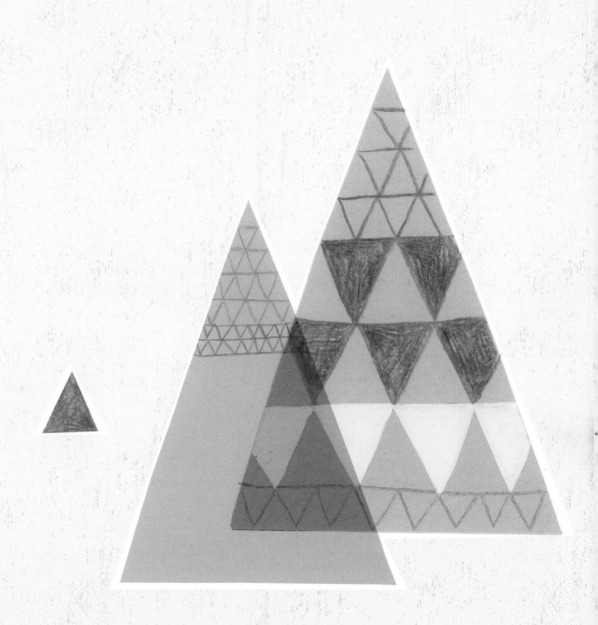

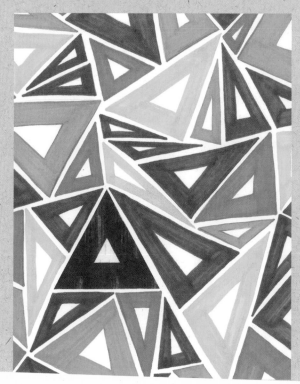

Is it a triangular traffic jam?

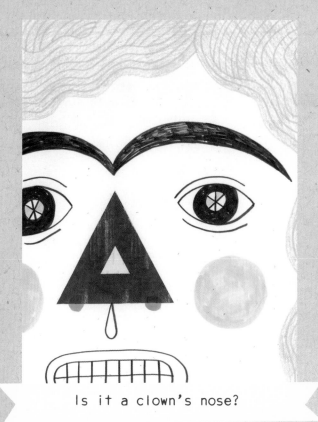

Is it a clown's nose?

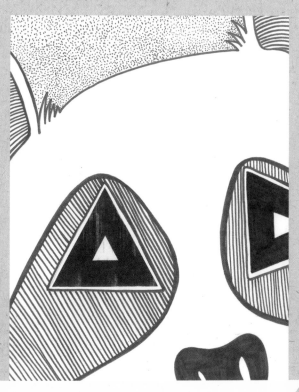

Is it a panda's eyes?

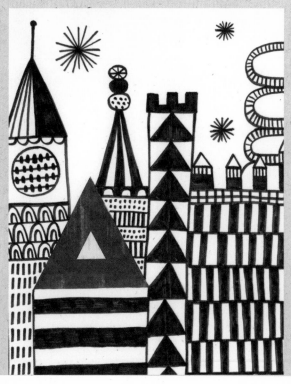

Is it a fantasy skyline?

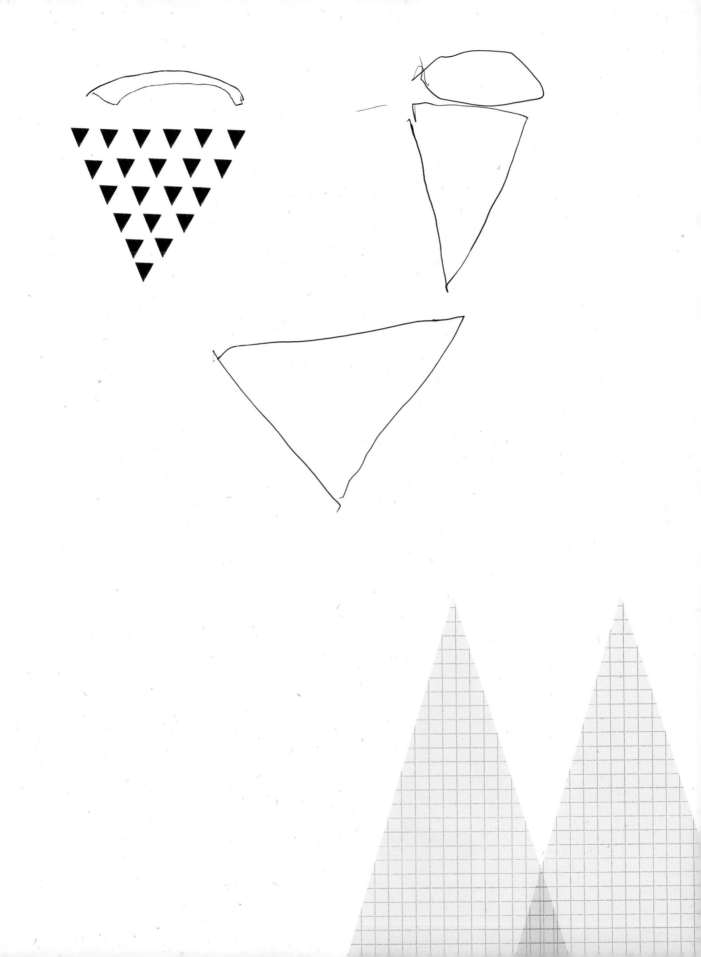

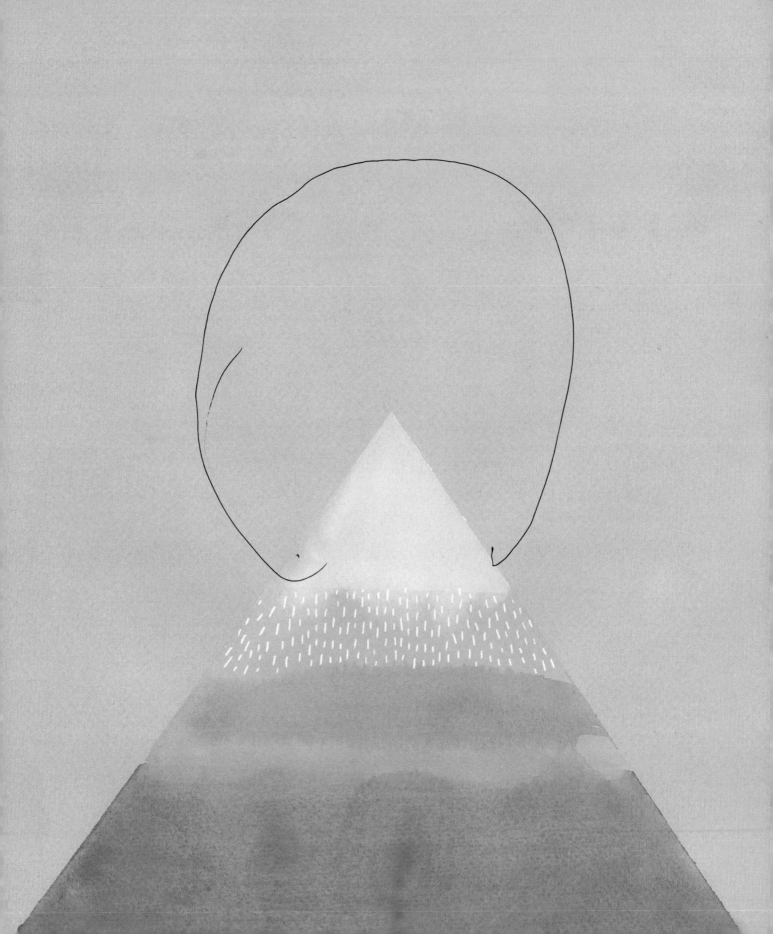

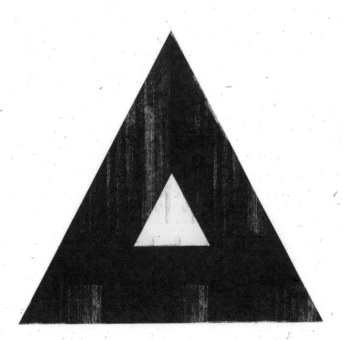

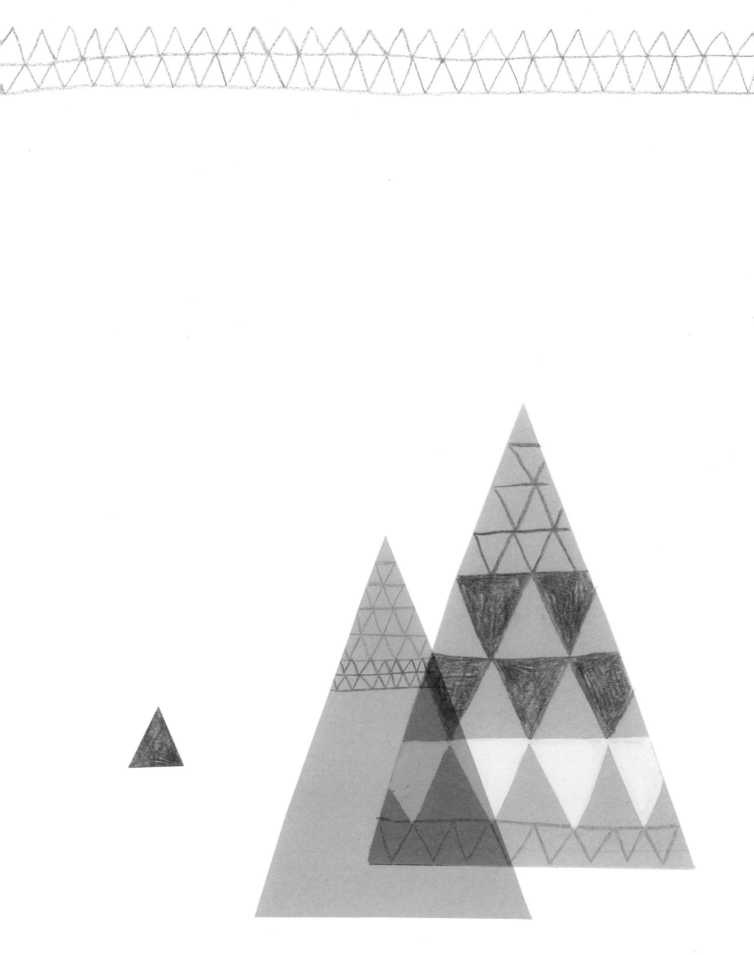

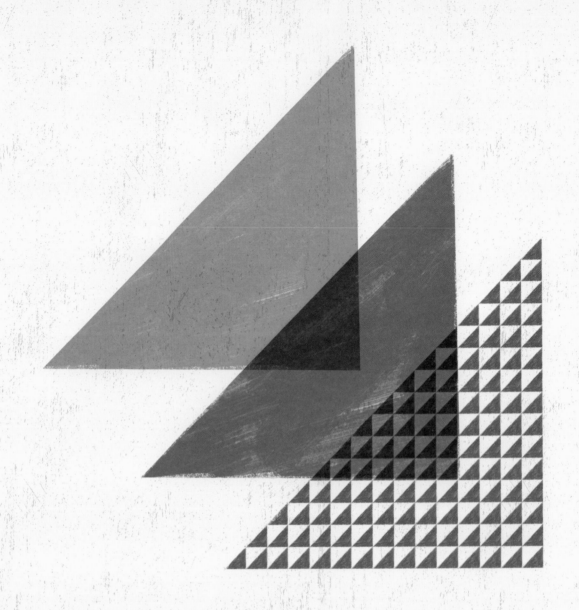

ly
y he
raphe
gular pl
as do oth
would do
credit union
on idea.

r
gs
f int
uring
ares own
f the State
For supply.
one of the sim
building

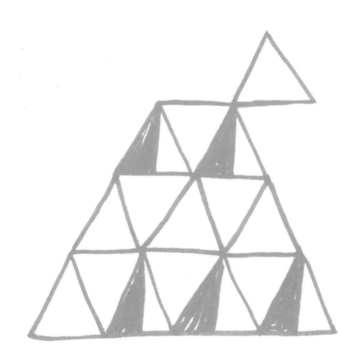

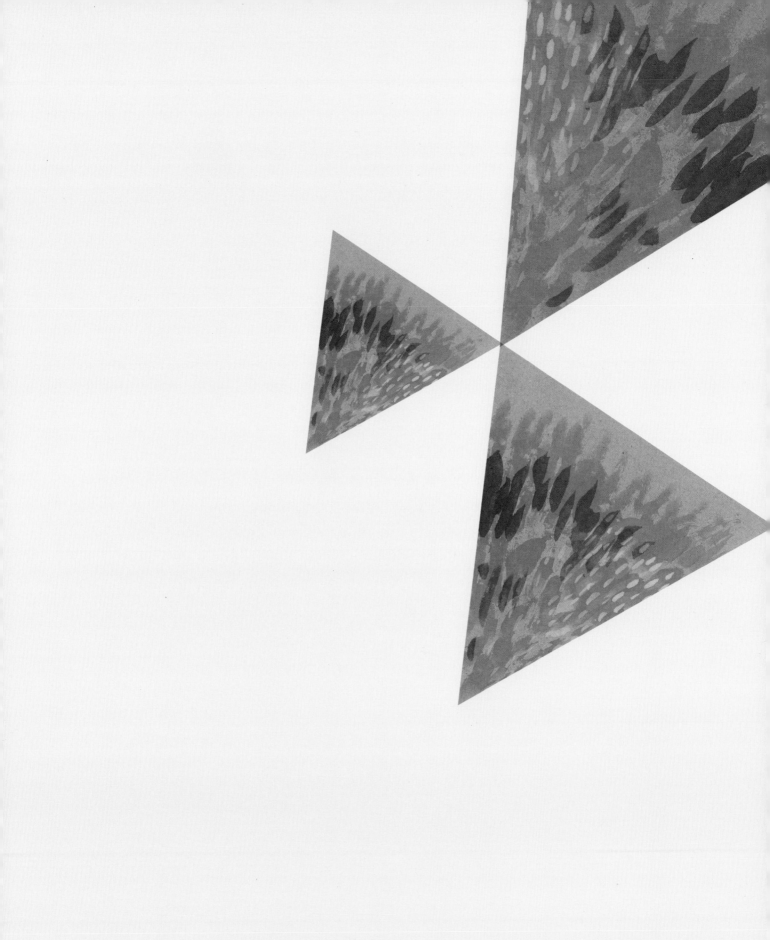

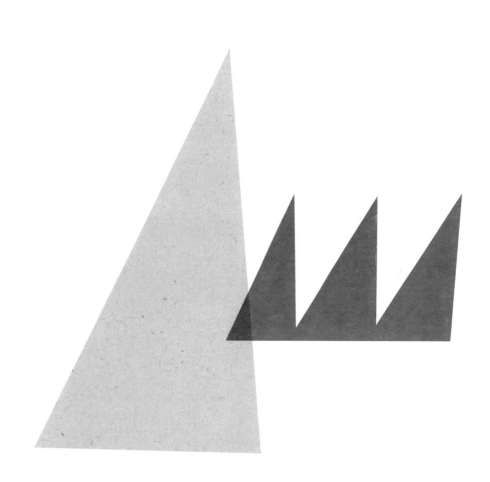

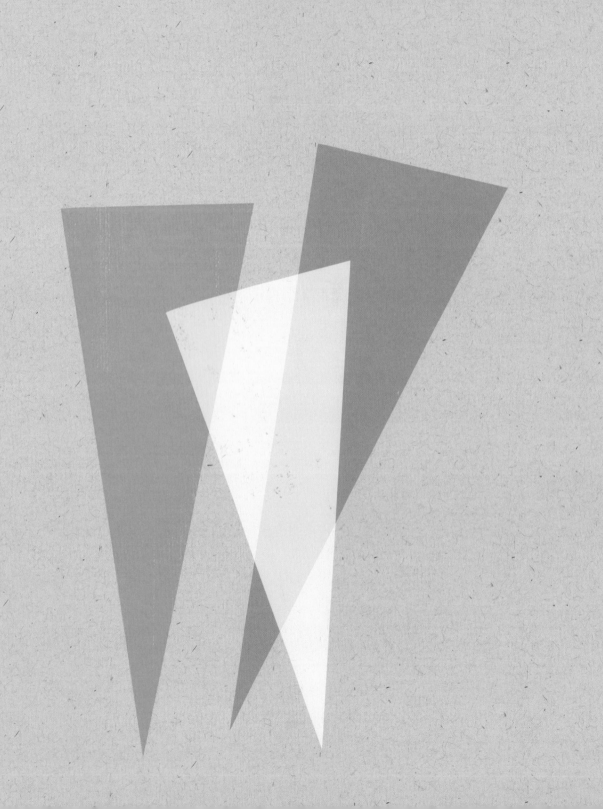

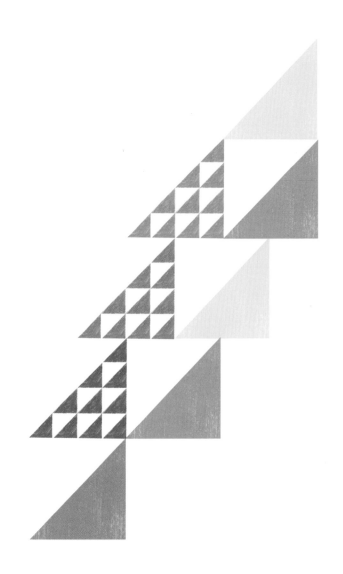

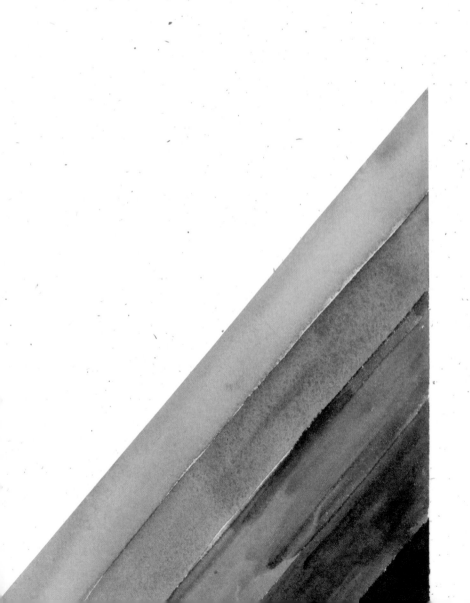

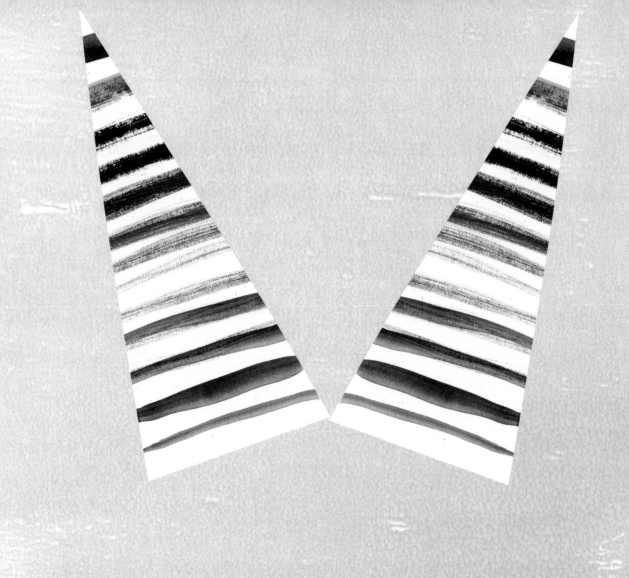

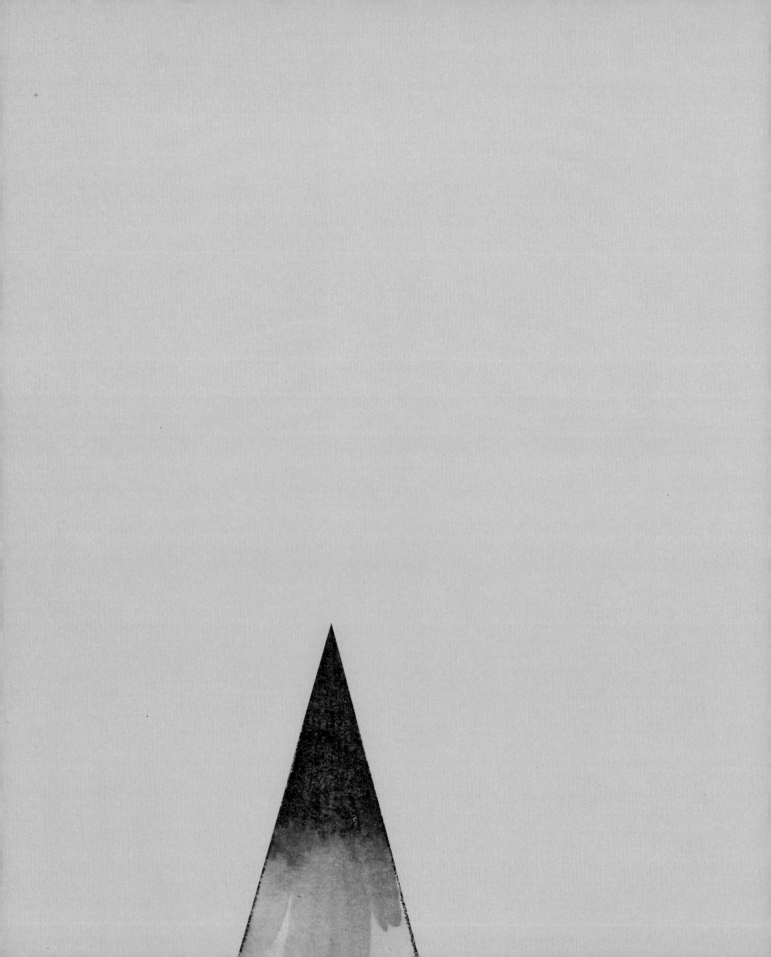

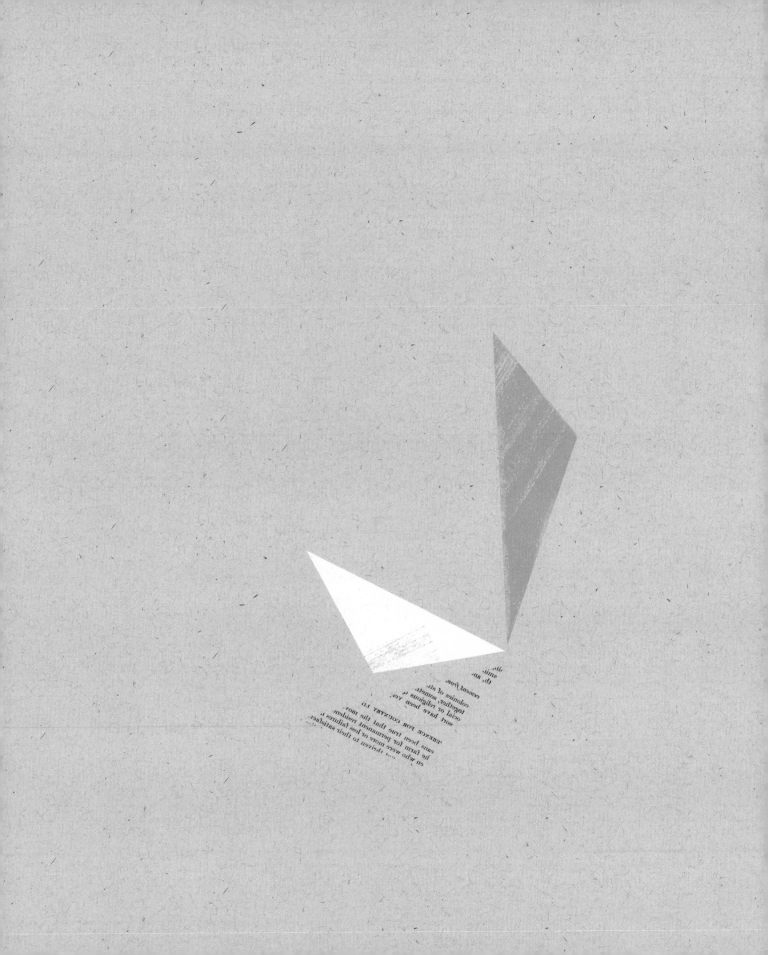

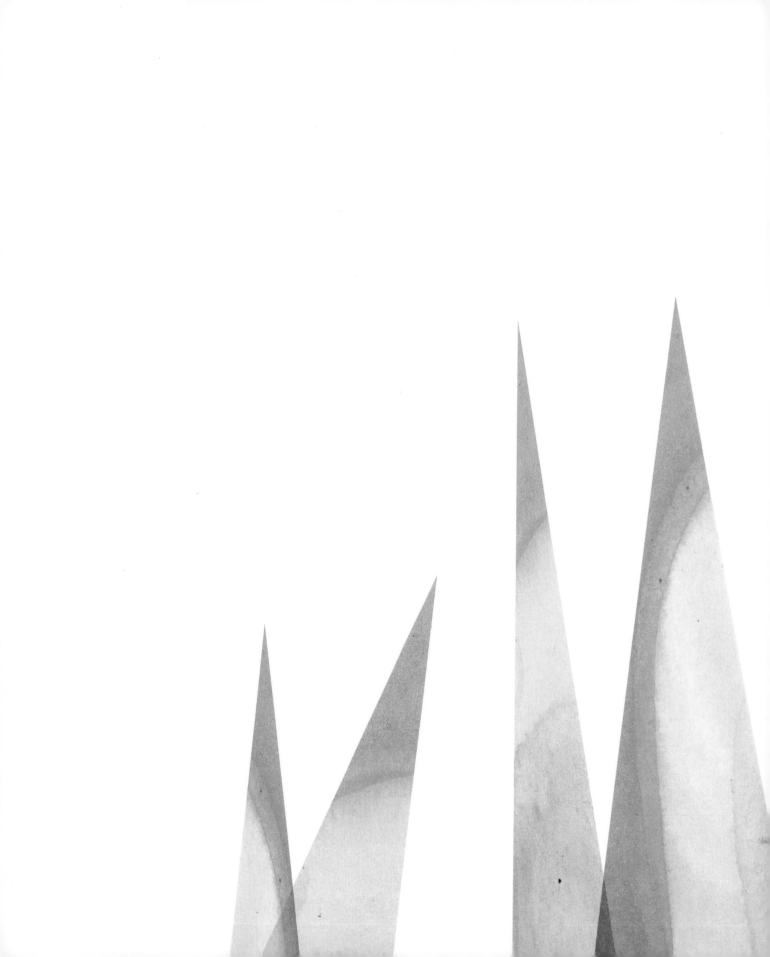

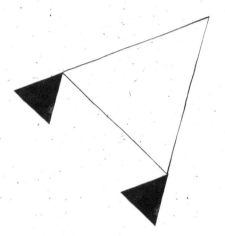

HOW TO DOODLE THIS PAGE

What do you see? Draw what you see.

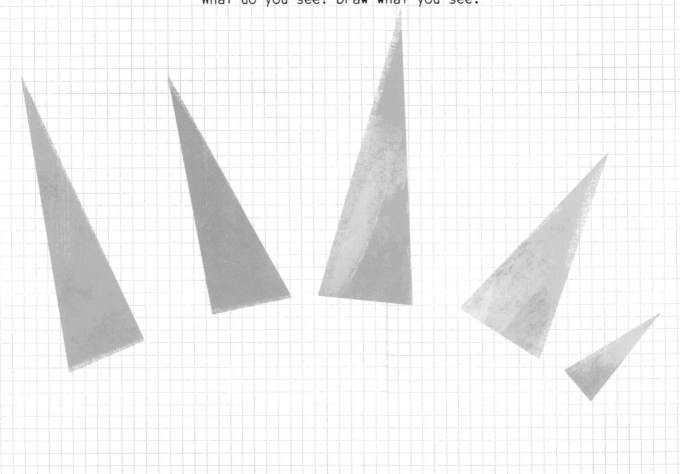

Is it a five-carrot necklace?

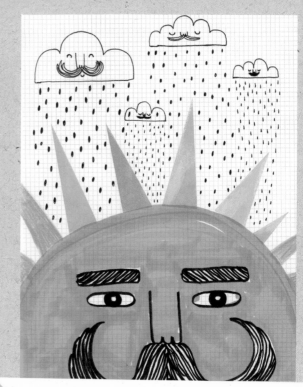

Is it the sun's rays?

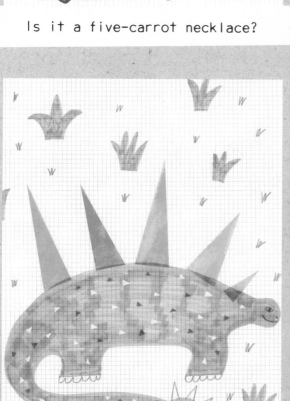

Is it a dinosaur's spine?

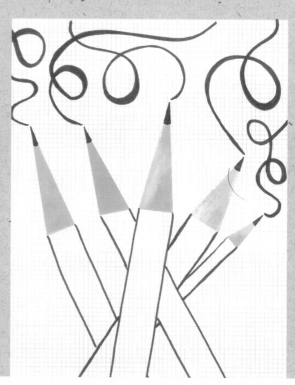

Is it the pencils' points?

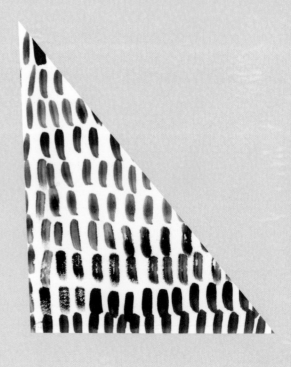

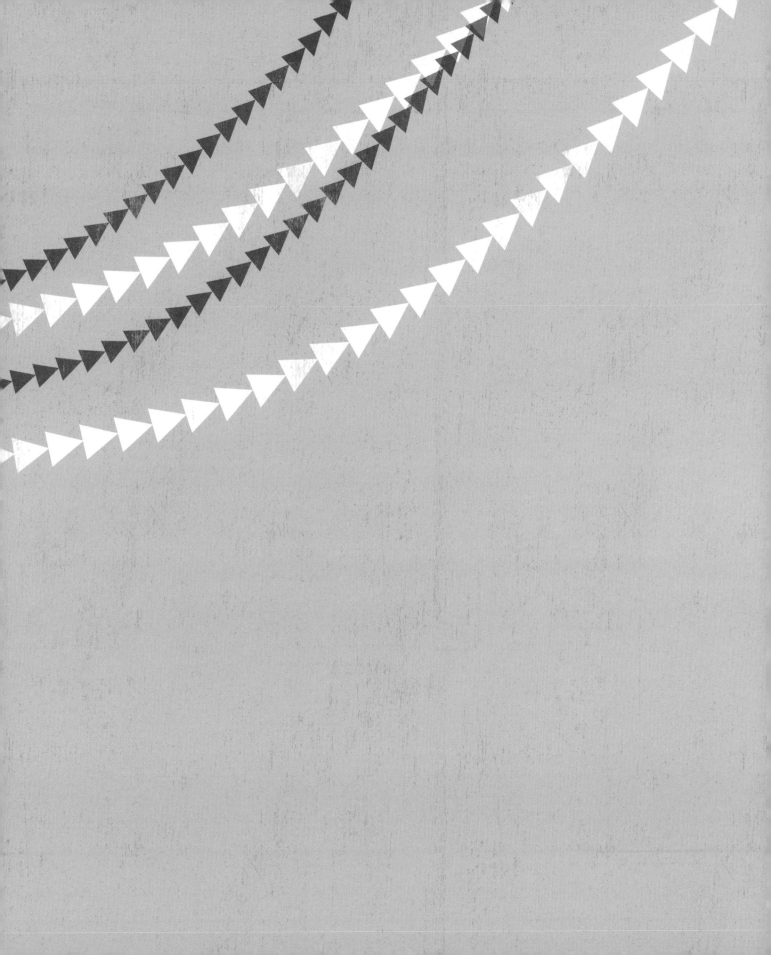

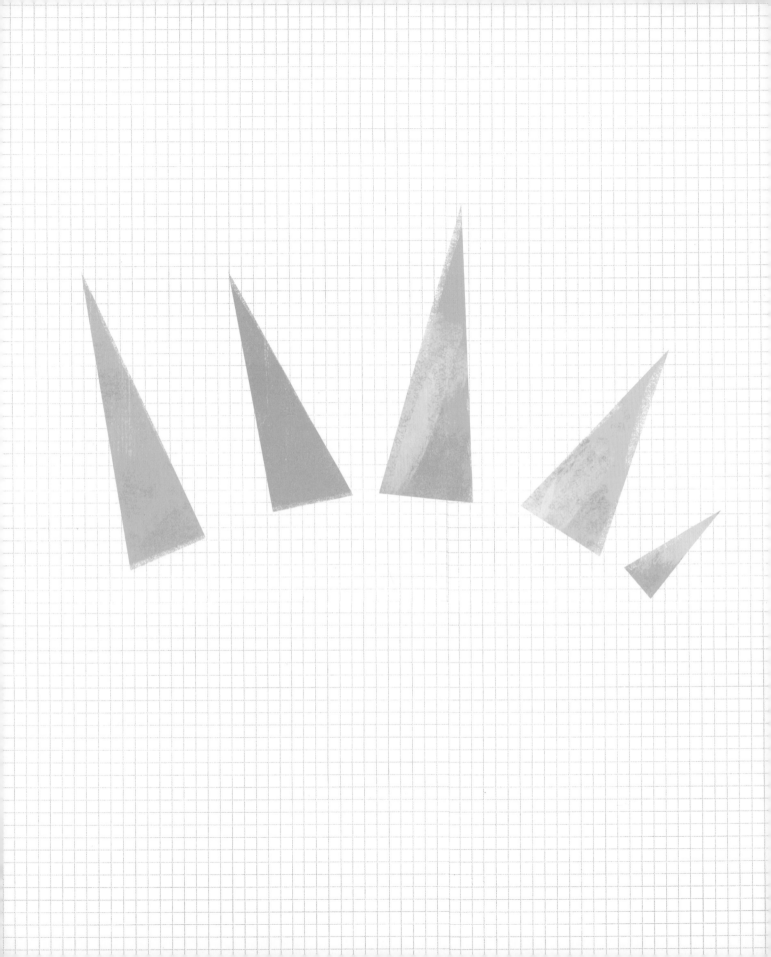

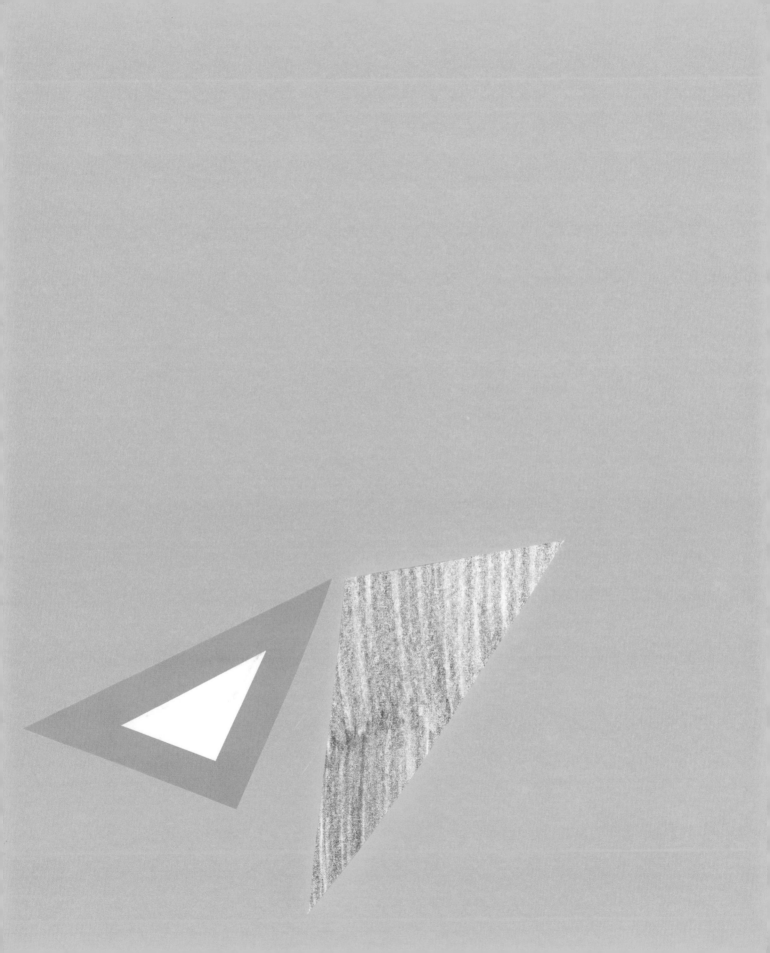

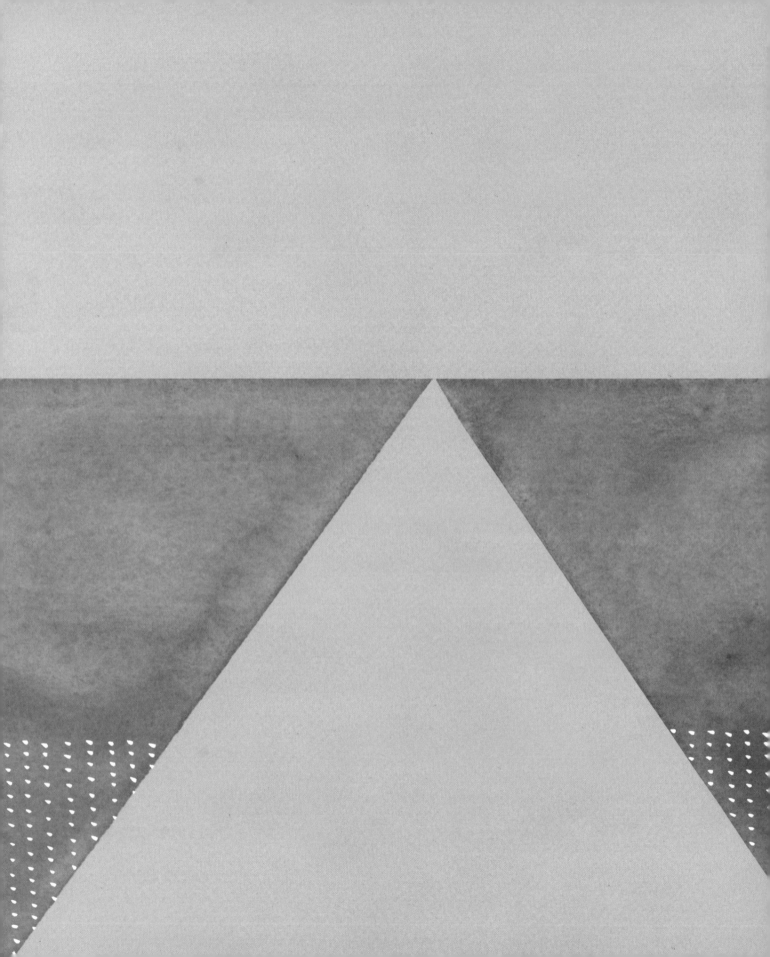

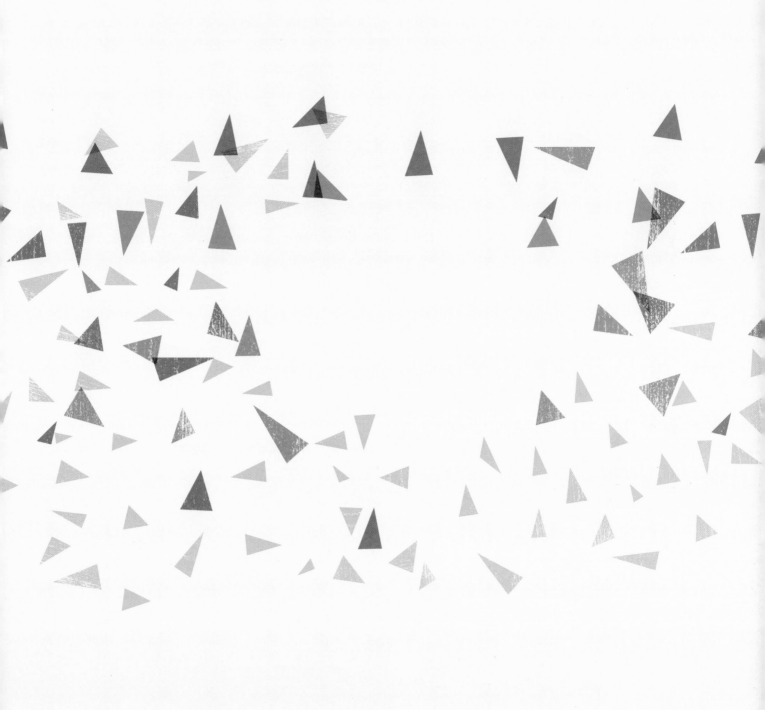

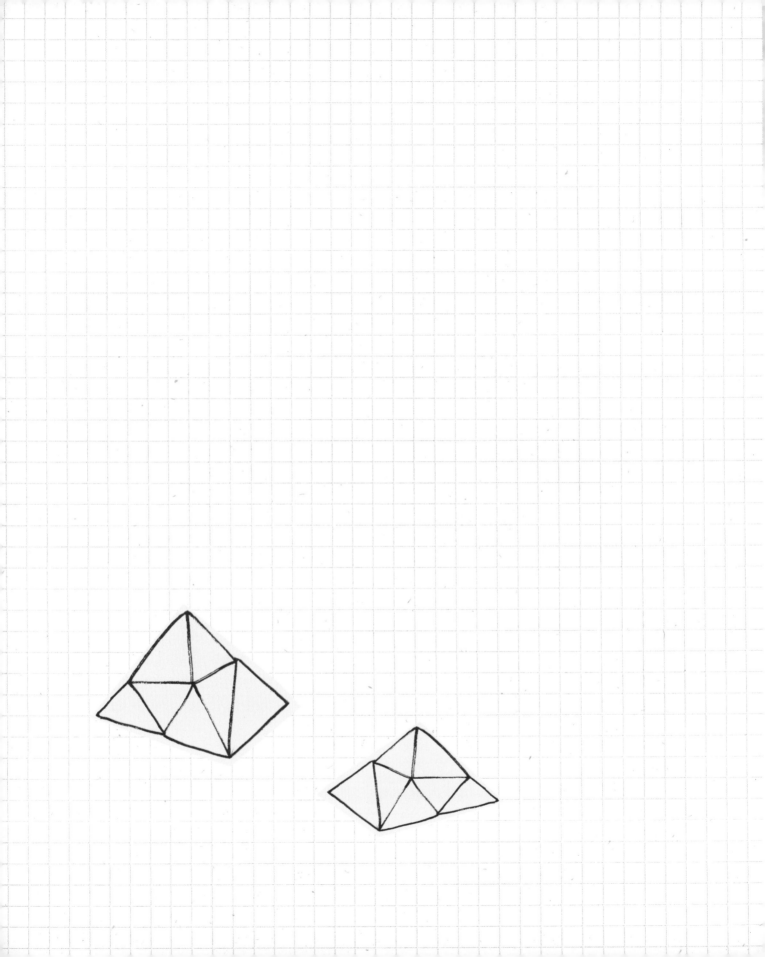

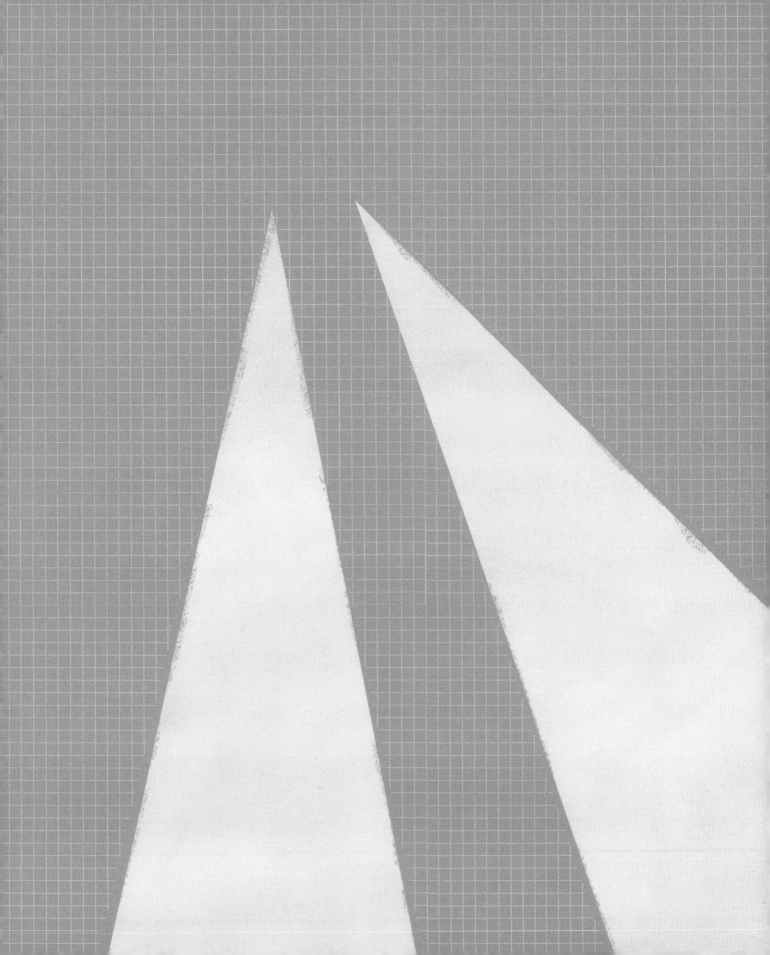

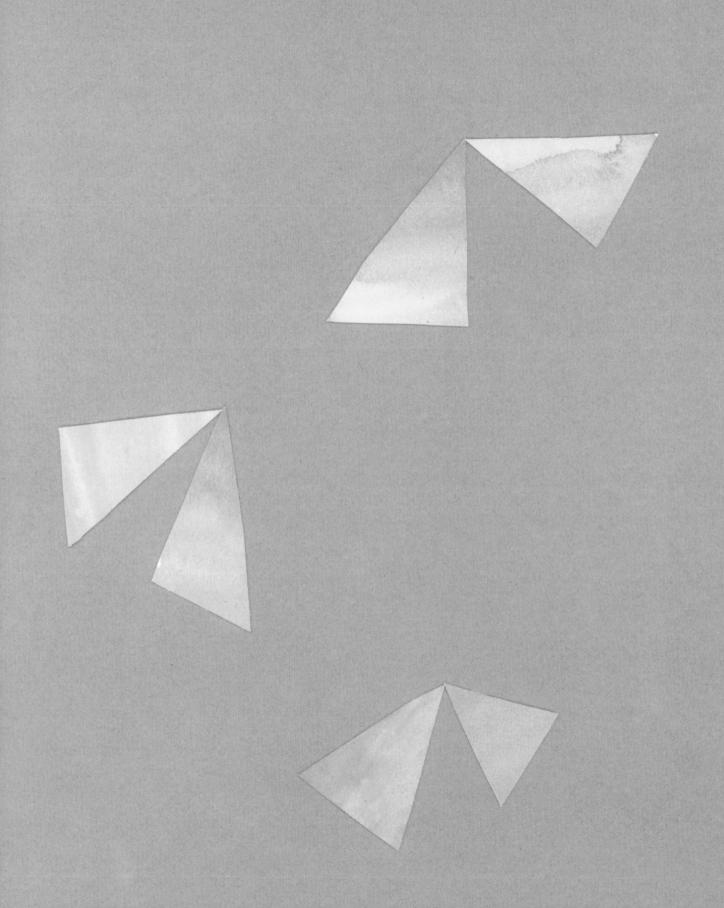

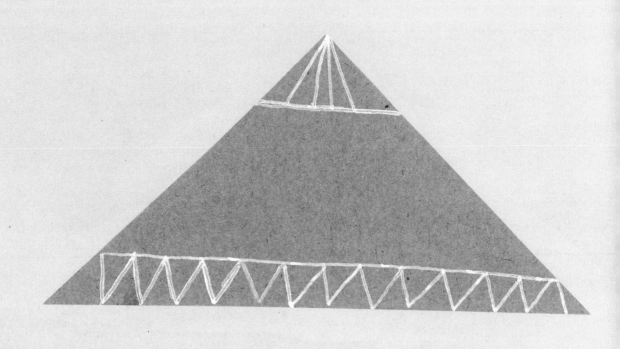

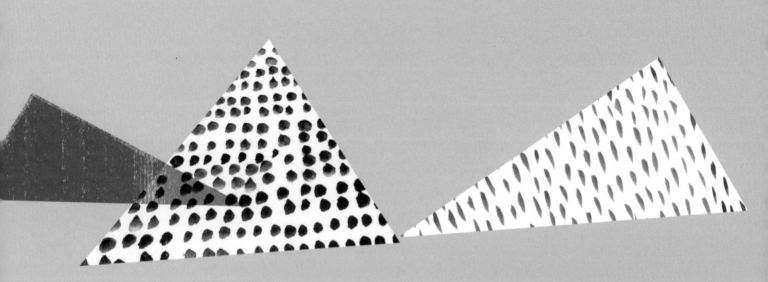

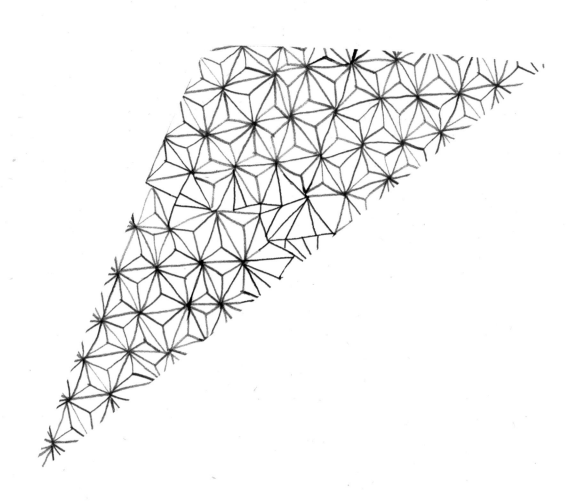

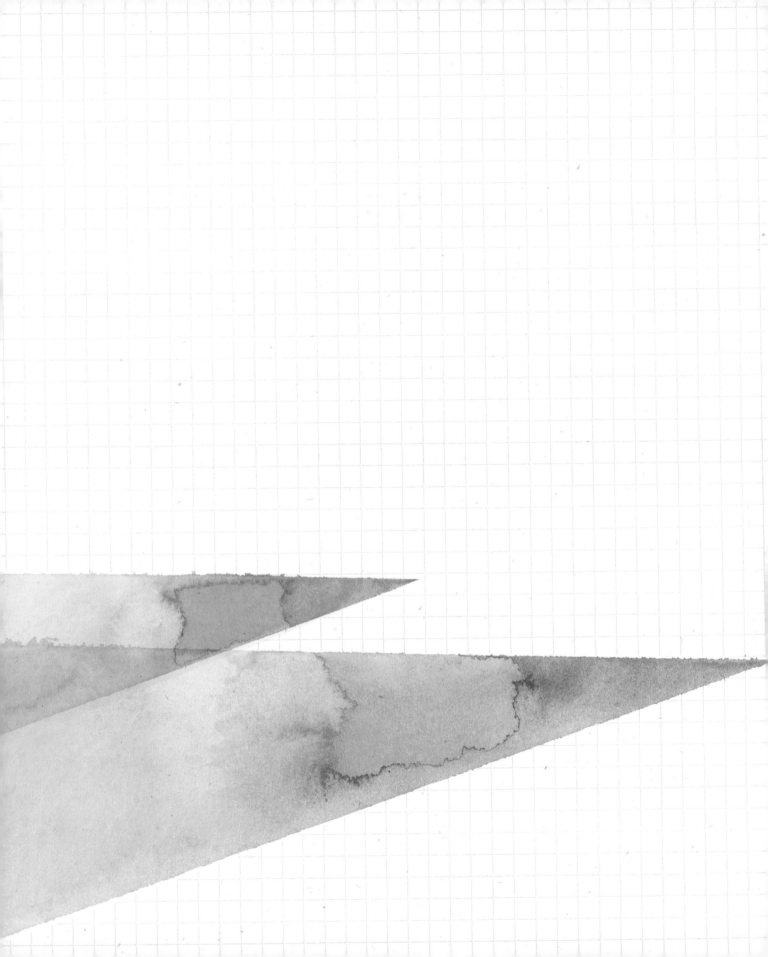

HOW TO DOODLE THIS PAGE

What do you see? Draw what you see.

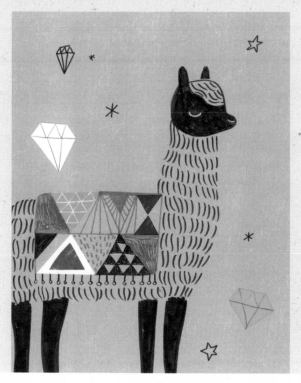

Is it a llama's pajamas?

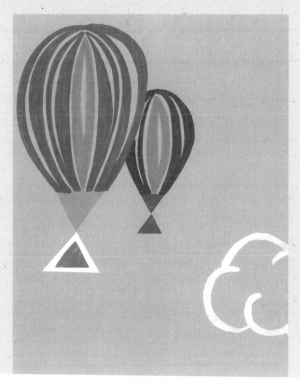

Is it a ride in the sky?

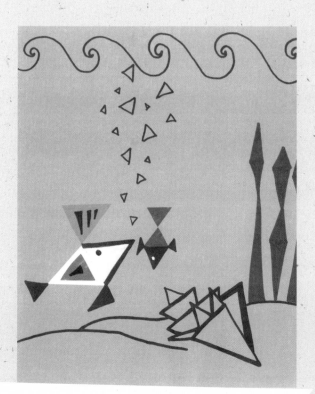

Is it a fish's milieu?

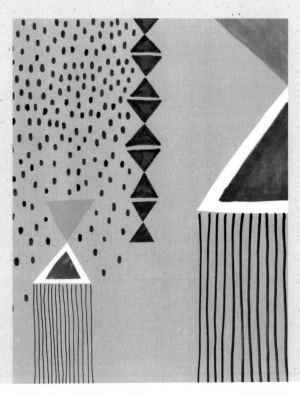

Is it an abstract view?

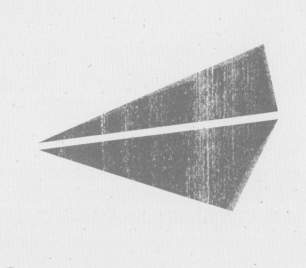

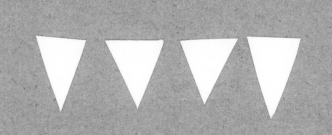

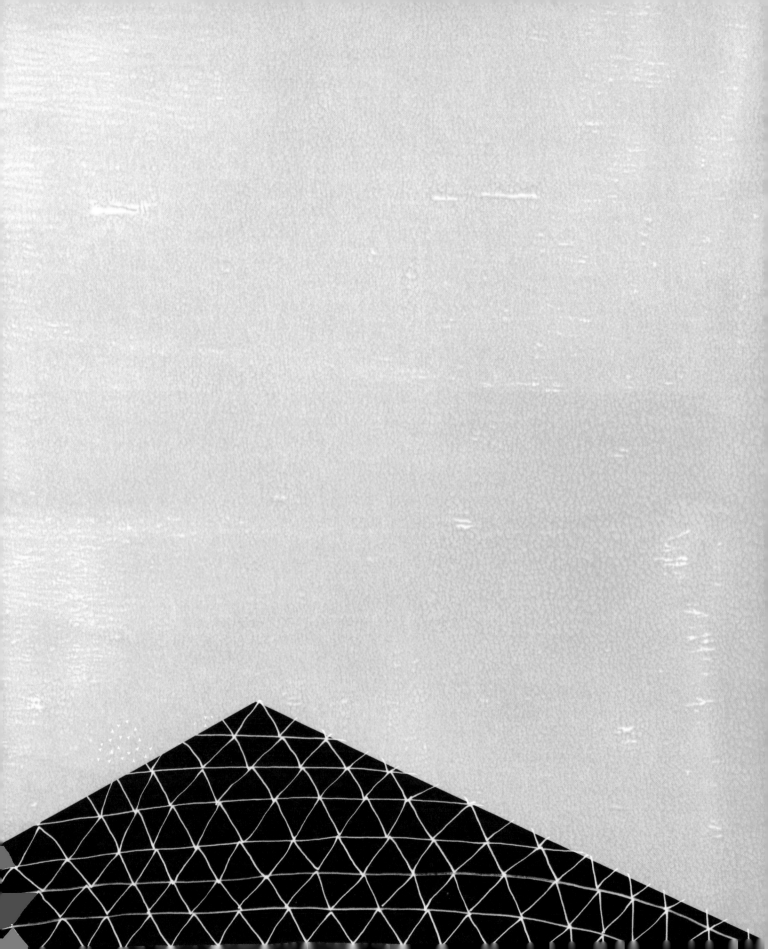

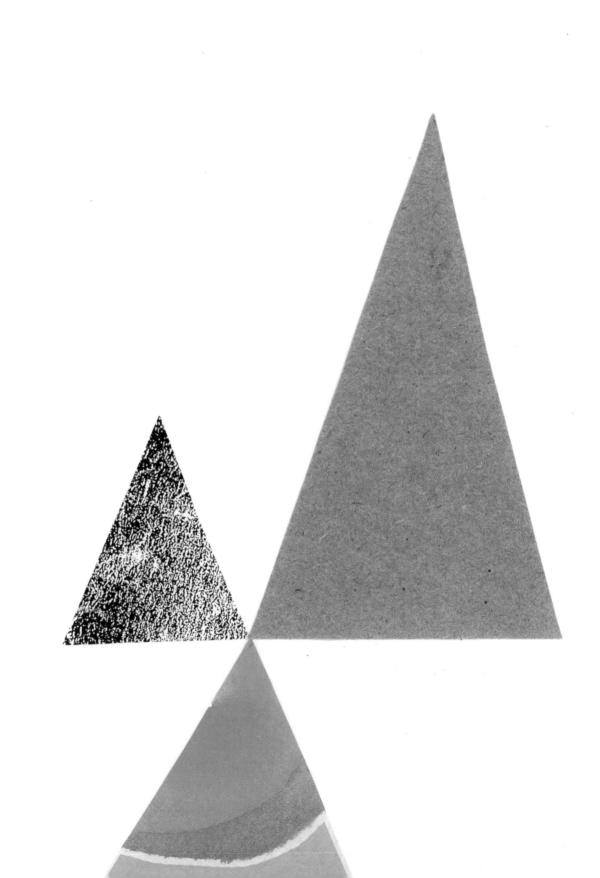

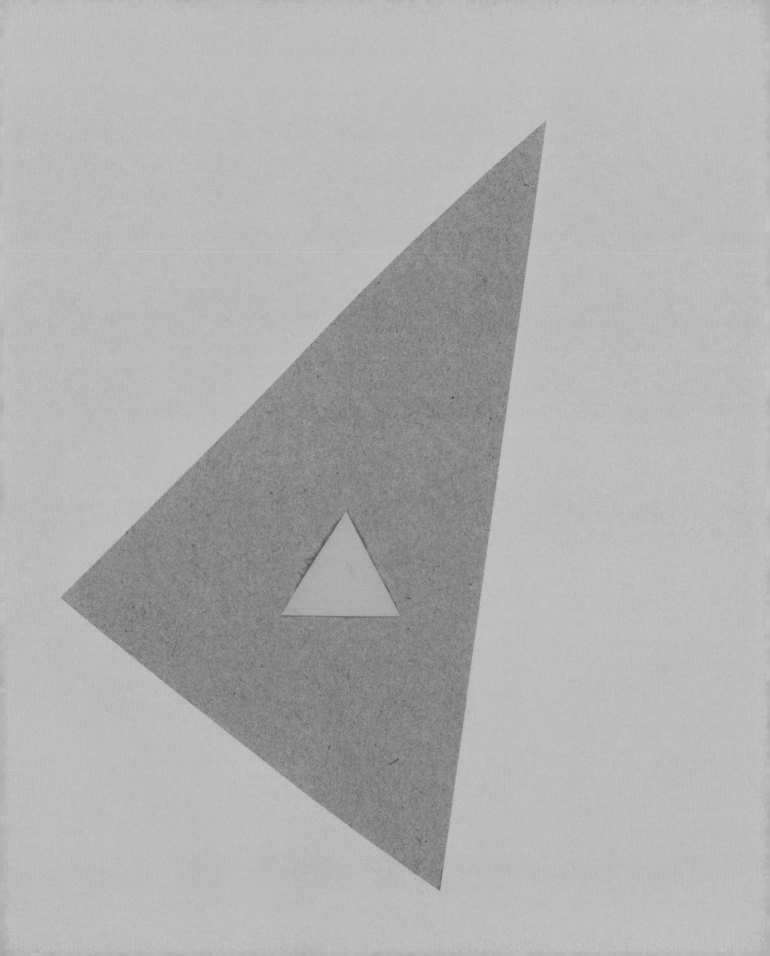

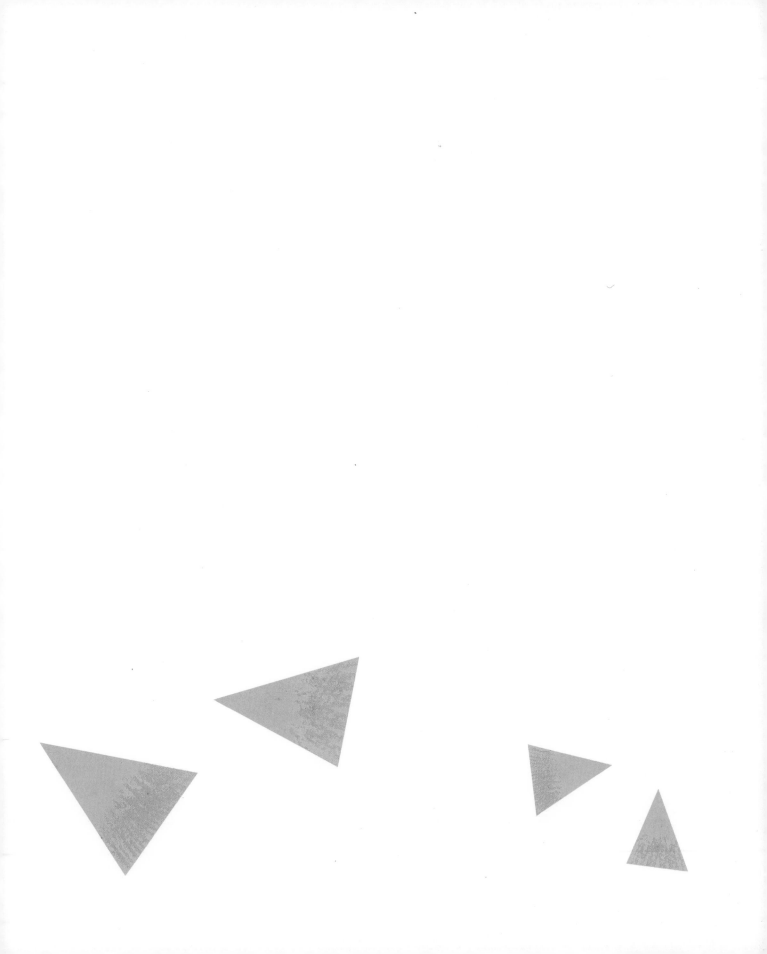

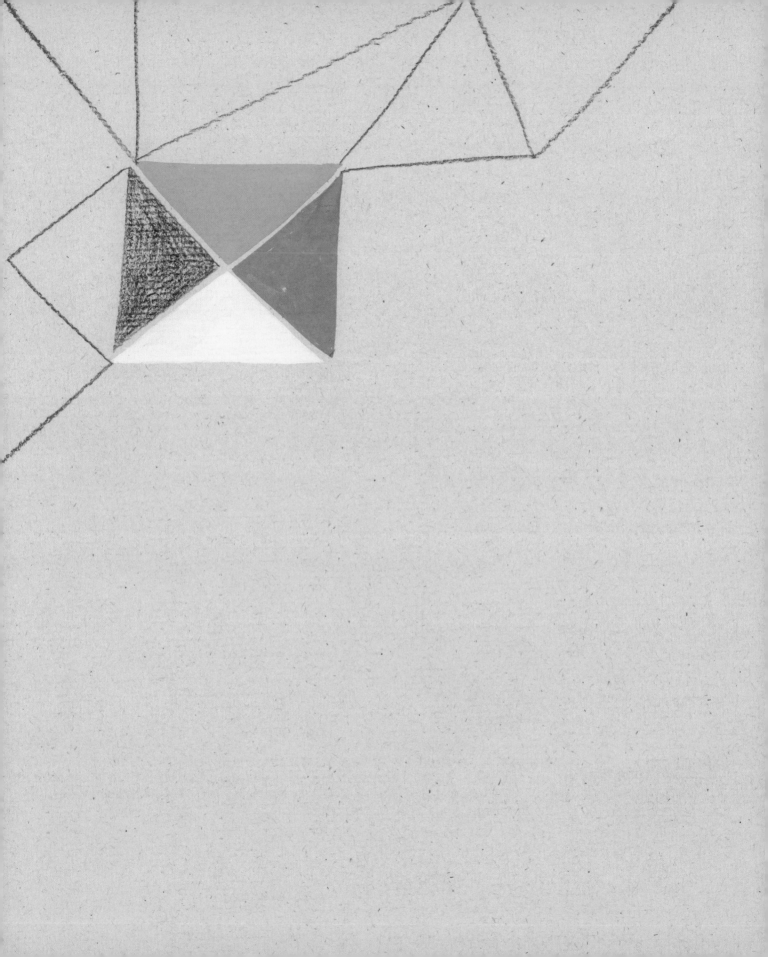

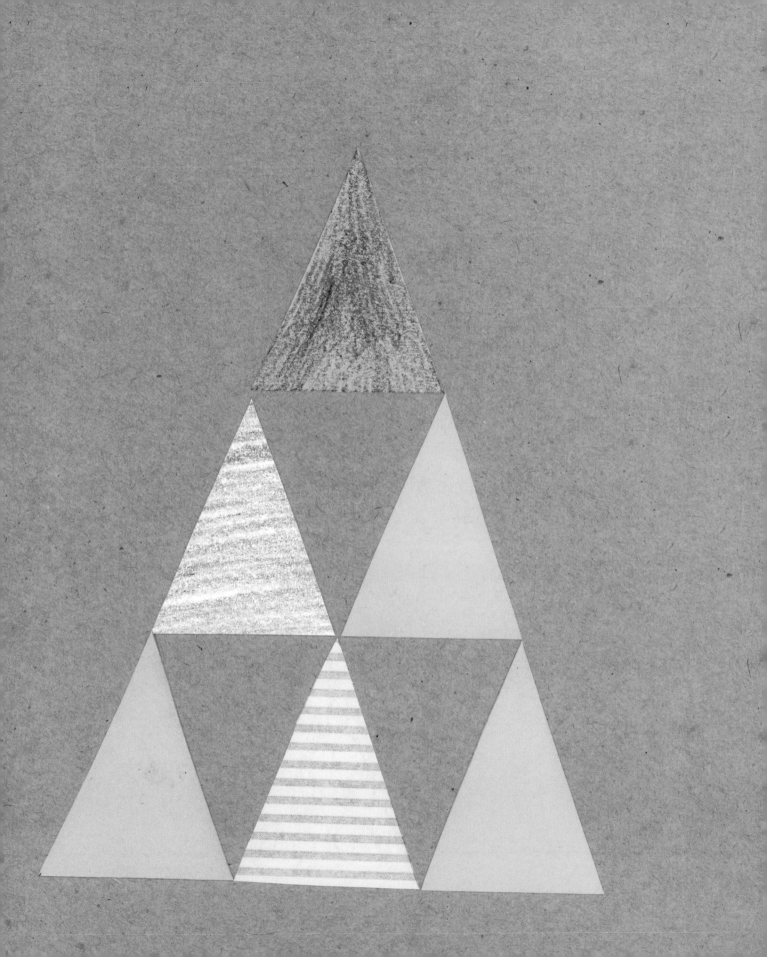

uropo
nporari
suffic ena

been establi and
ompetent ou that
n colonies in of con
and the Salv Other
better he

of Agriculture.

that the money r.
Some of th se youn Agricultural
the farm after finding that were held t
city. some bond of soc
ve gone to the city have colonies of this se
siness, perhaps with insuff dozen years.
and some of th se men hav

PREFERE

it was discovered has by no means
s movement "retired ty and town to the far
n with the expectation of luded only those men who
ays there, but had become nes occupations, men who have
e to be short of expectations. and men who have desired
ppened that men who have passed n employment for wages. This
advanced in city occupations as they h men of means and agricultural
es with small means and with their eco who have accumulated a compet
ning more and more unpromising. Thes been forced out to the farm by ec
ted considerably to the movement to ag have followed lines of economic pl
erably in numbers, but not usually so in country life, and with some of them
While most of them have been farmers' s deferred realization of a dream of happ
d in the country

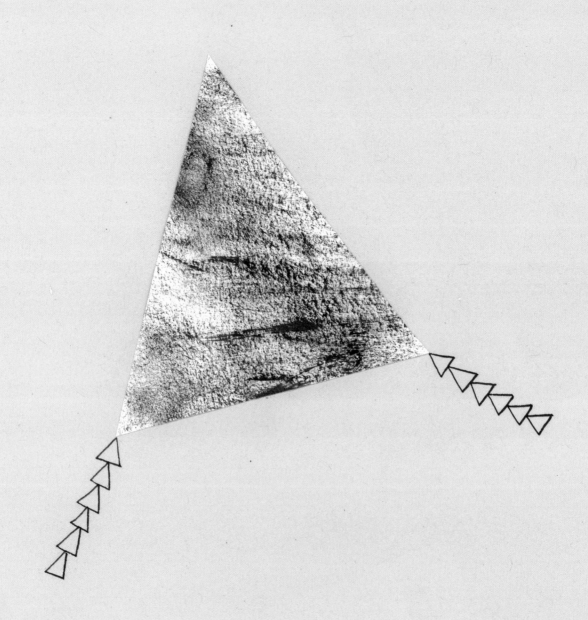

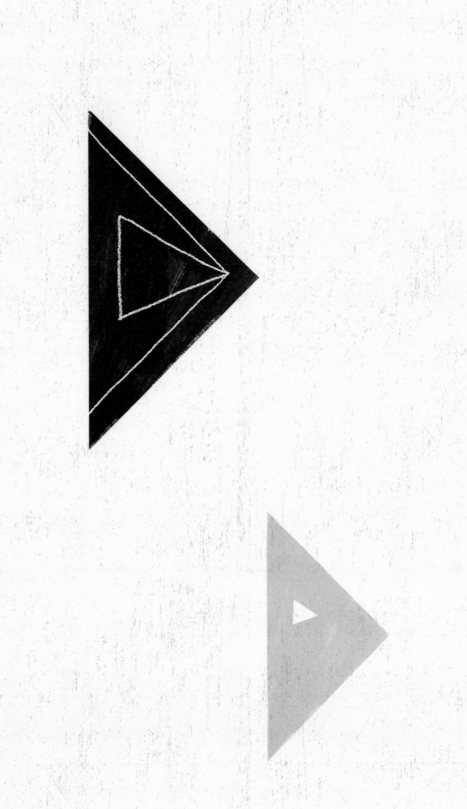

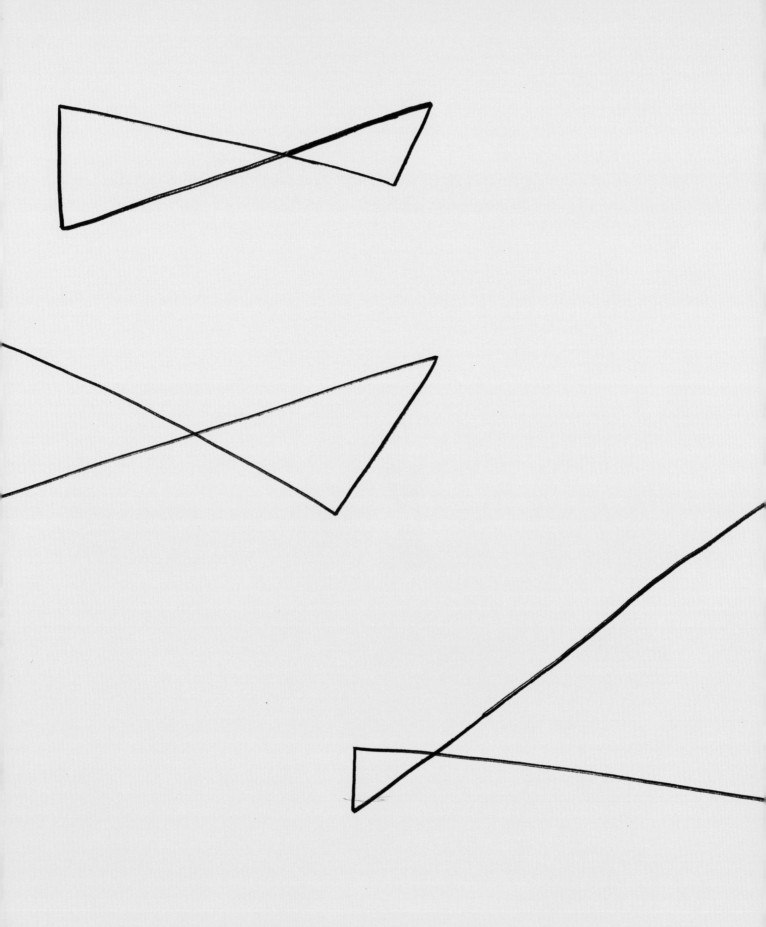

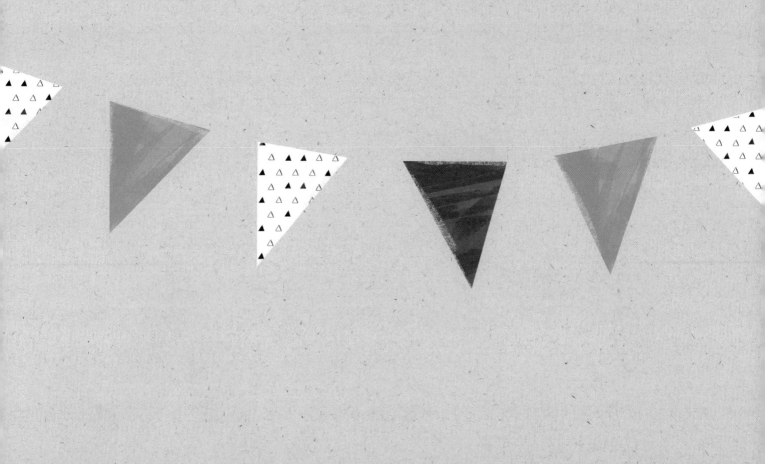

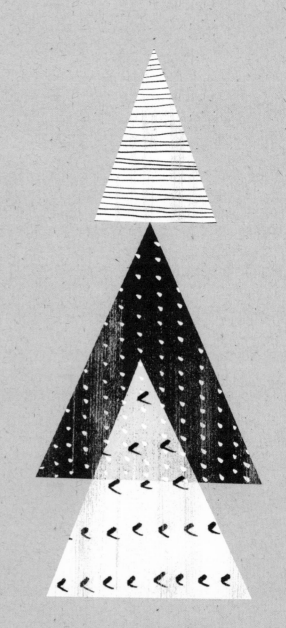

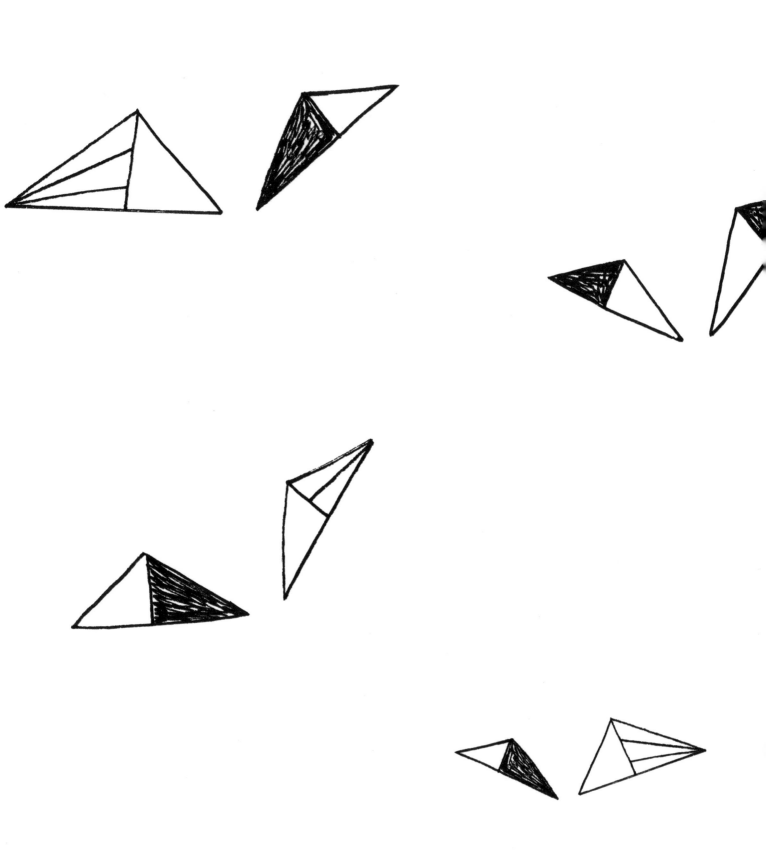

HOW TO DOODLE THIS PAGE

What do you see? Draw what you see.

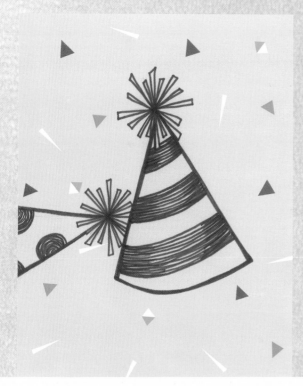

Is it the start of a party?

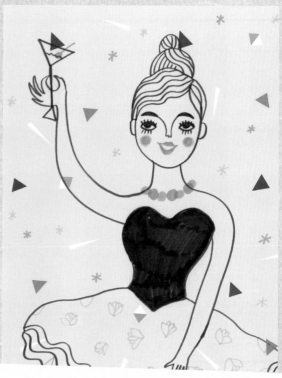

Is it a New Year's toast

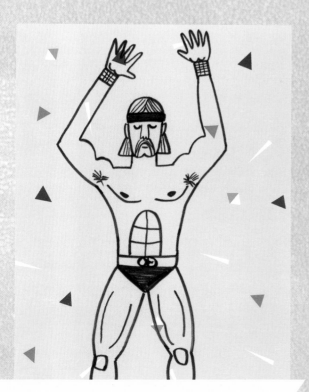

Is it a dynamic aura?

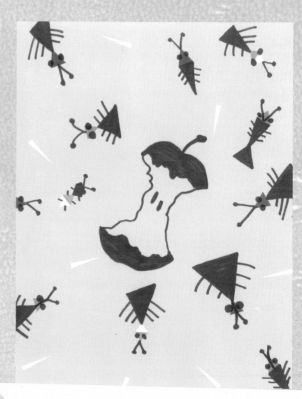

Is it a bug's paradise?

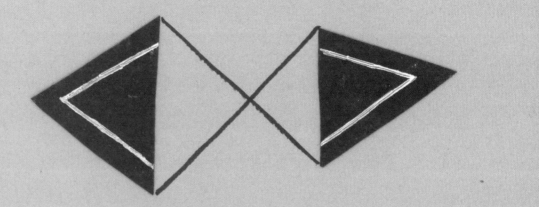

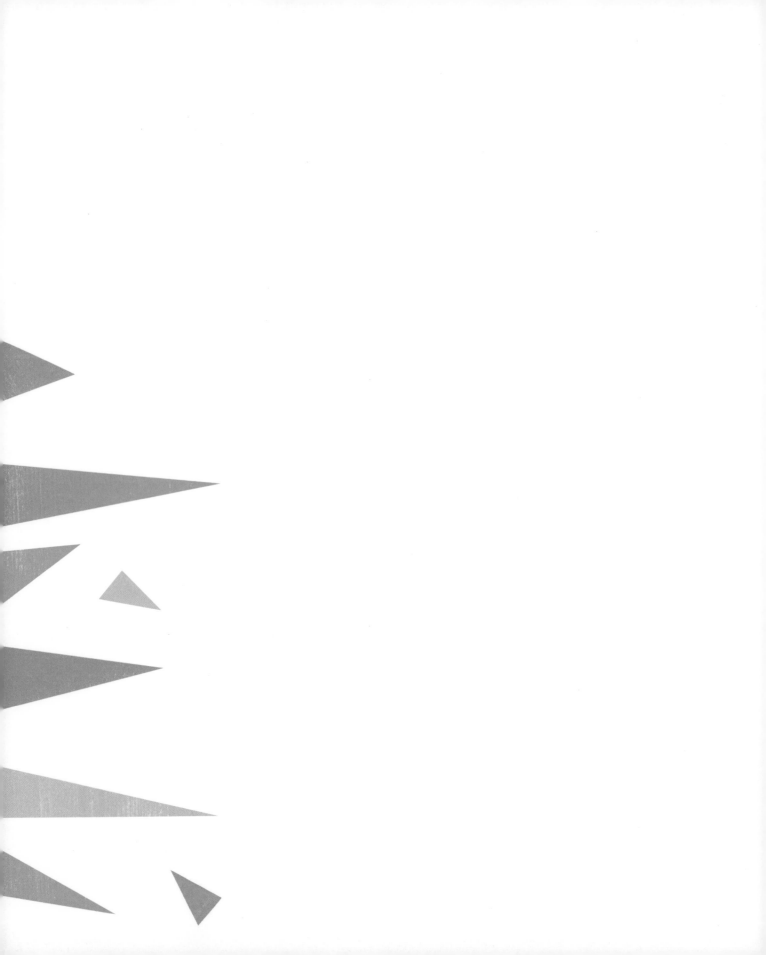

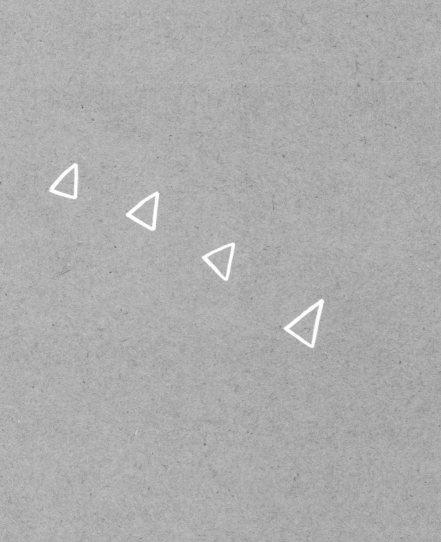

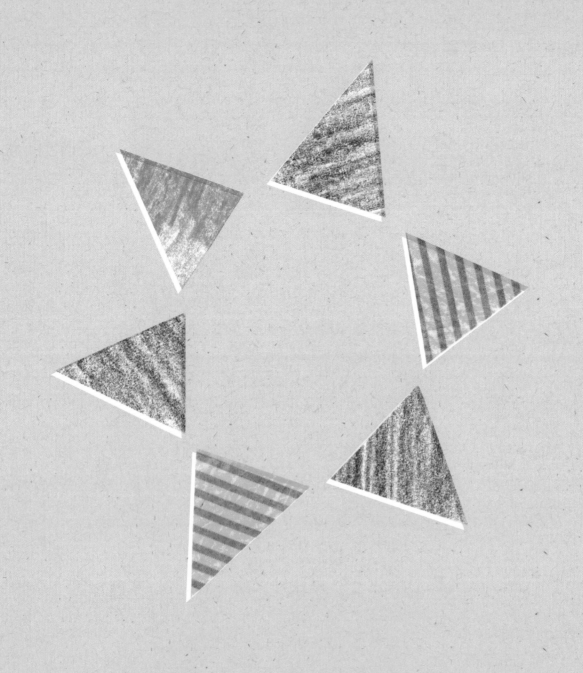

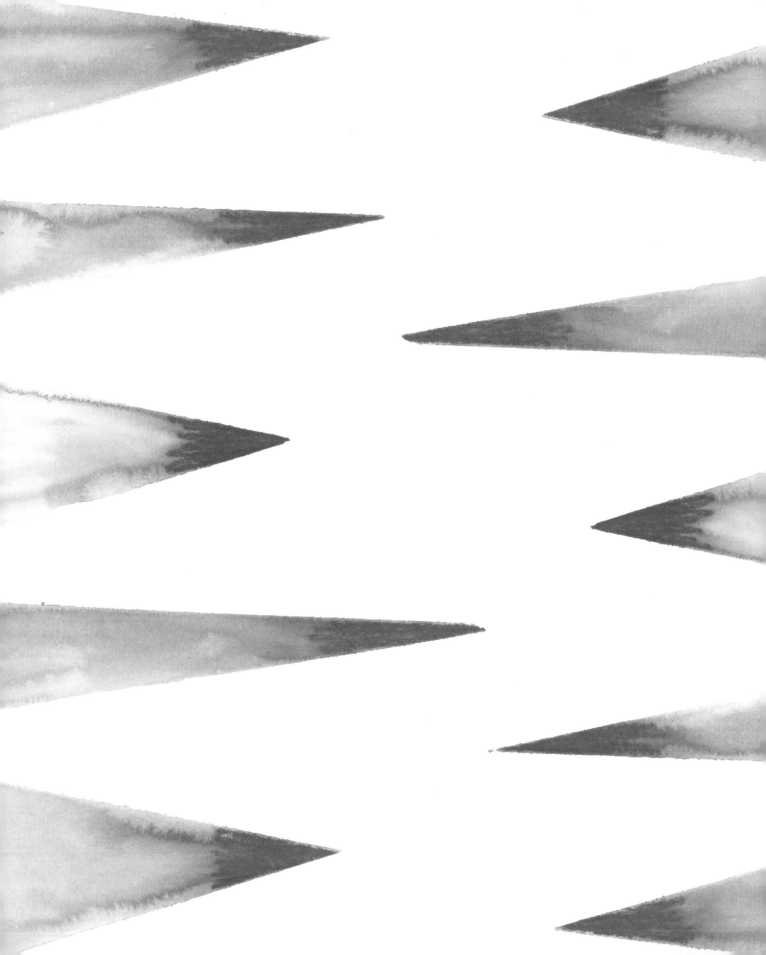

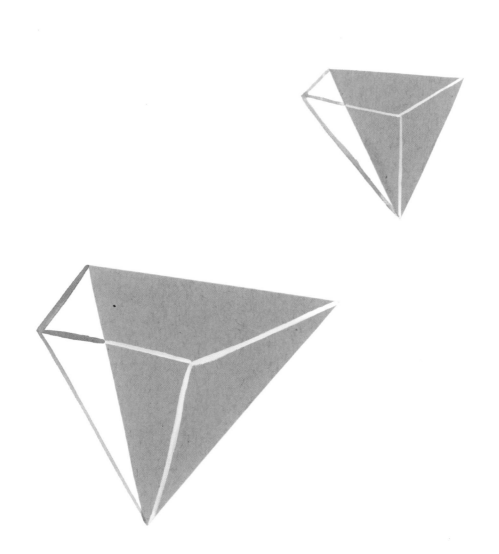

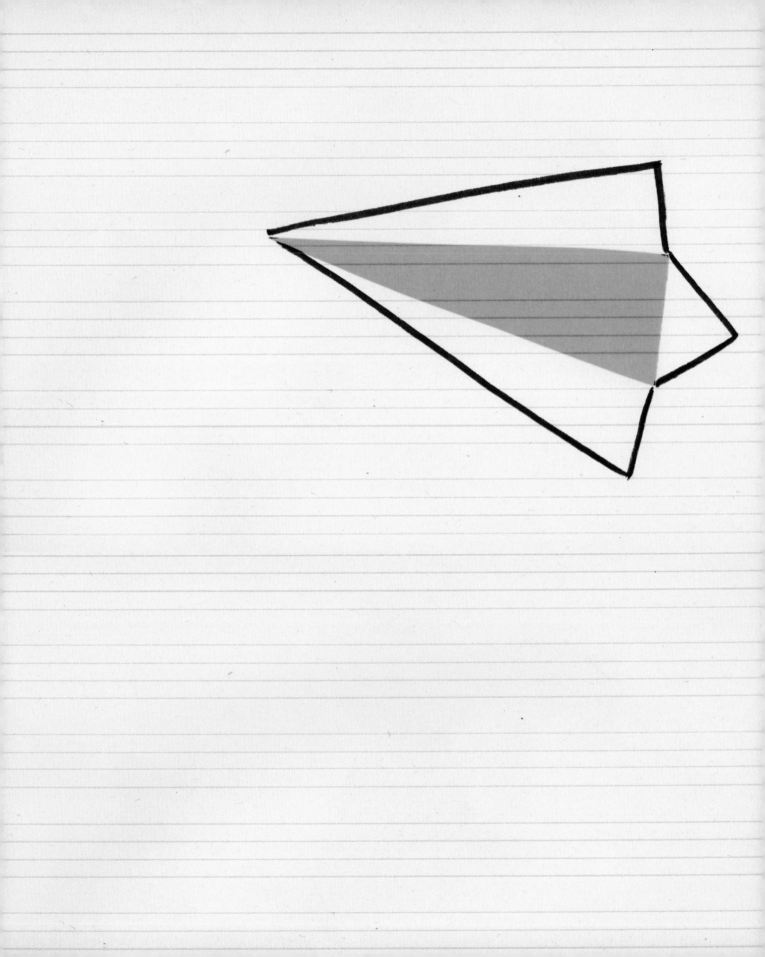

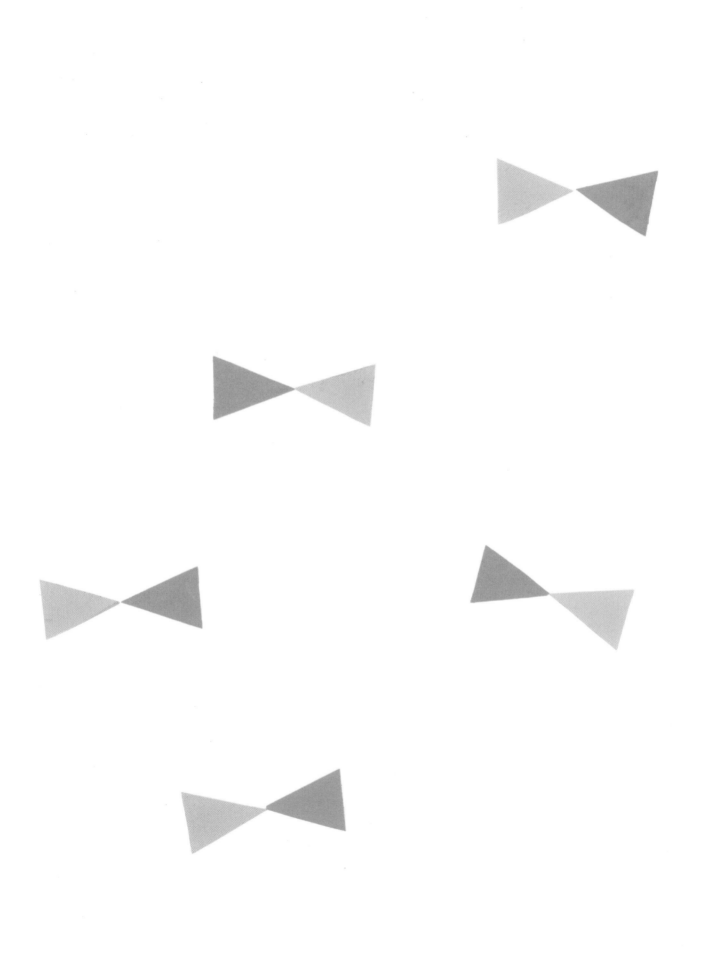

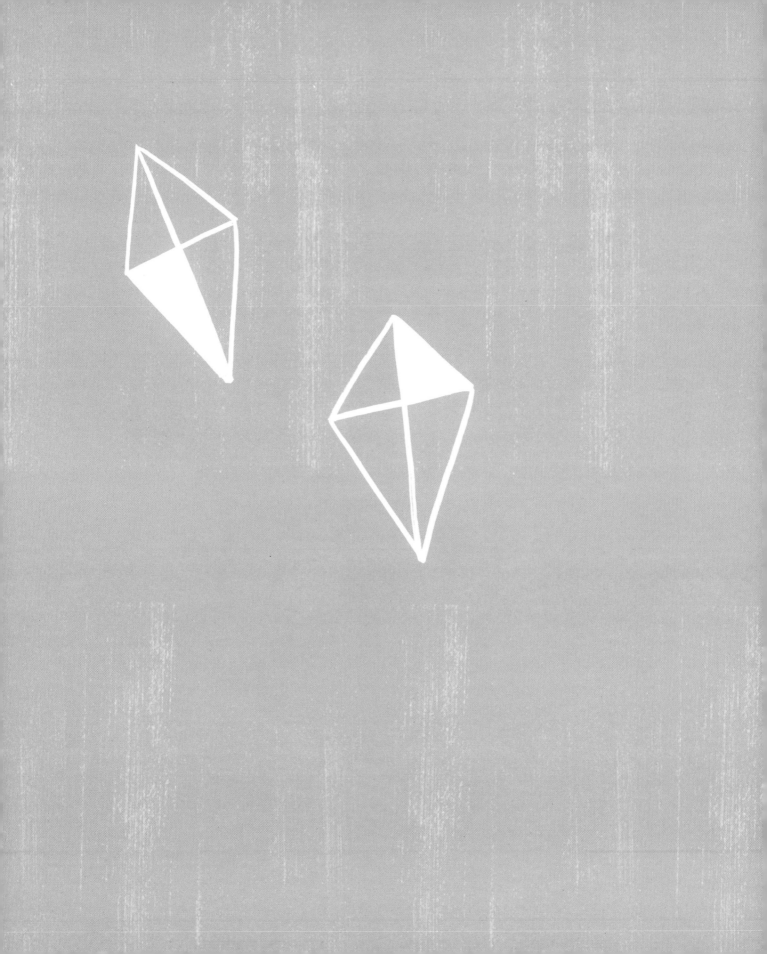

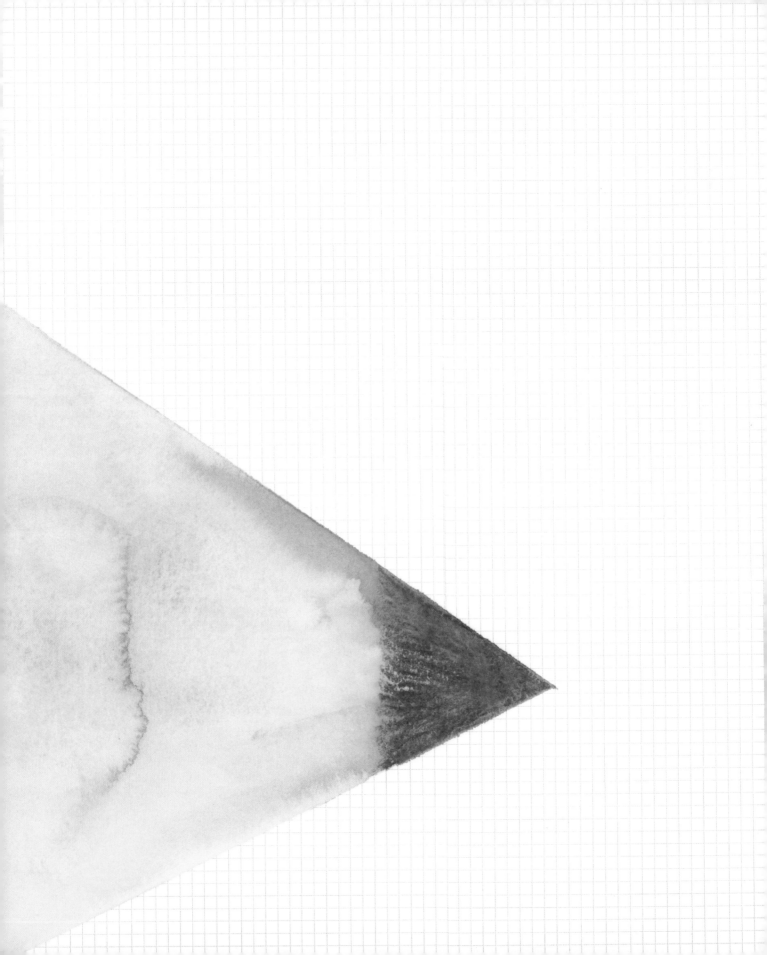

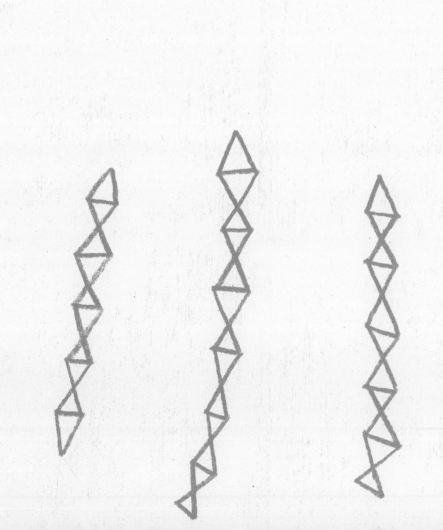

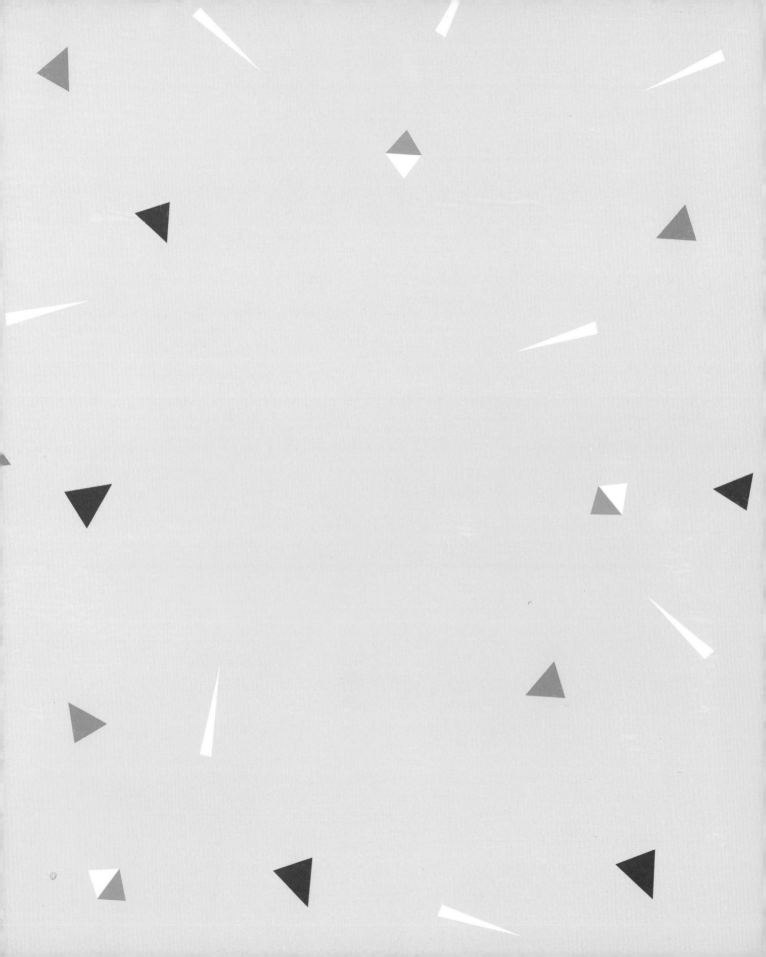

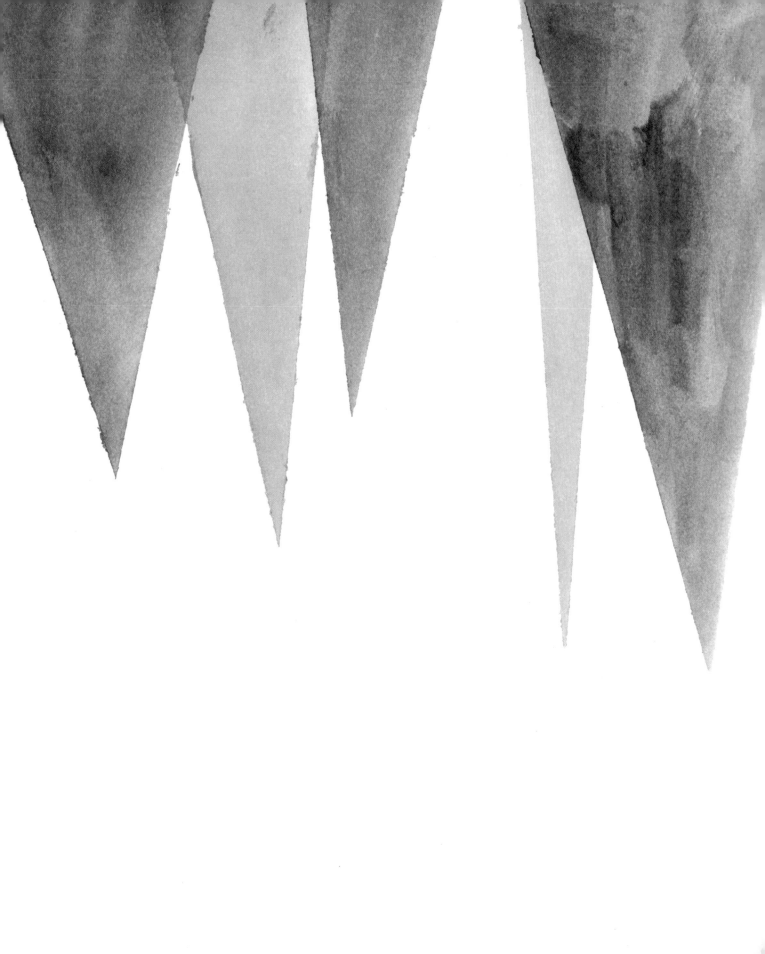

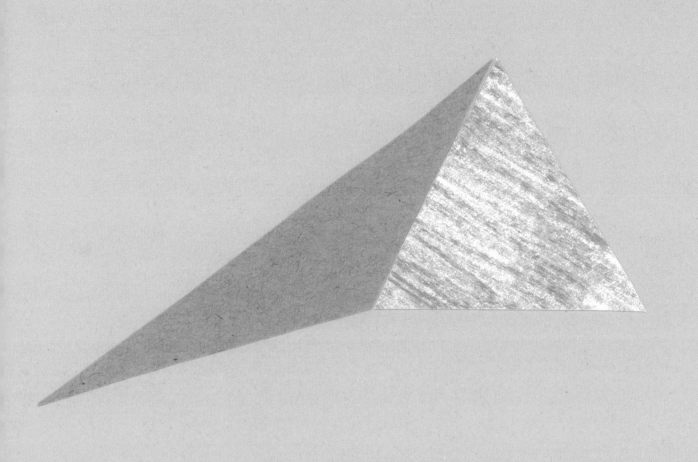

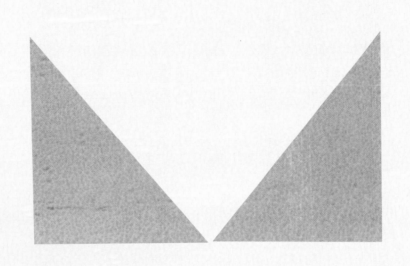

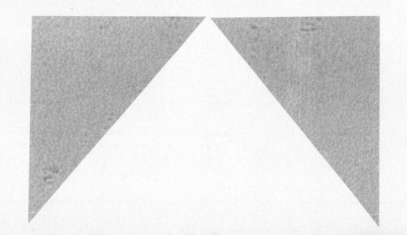

First published in the United States of America in 2016 by
Quarry Books, an imprint of
Quarto Publishing Group USA Inc.
100 Cummings Center
Suite 406-L
Beverly, Massachusetts 01915-6101
Telephone: (978) 282-9590
Fax: (978) 283-2742
www.QuartoKnows.com

10 9 8 7 6 5 4 3 2 1

ISBN: 978-1-63159-100-6

Design: Megan Jones Design
Cover Image: Sarah Walsh

Printed in China

About the Artist

Sarah Walsh is a Kansas City—based artist and illustrator. She's inspired by animals, magical creatures, coffee, music, a good story, her friends and family, bravery, vintage children's books, folk art, and mid-century anything. She is the author/illustrator of three Just Add Color series titles from Rockport: *Circus, Carnival,* and *Day of the Dead.*